Disney

VILLAINS

SPIROGLYPHICS®

Thunder Bay Press
An imprint of Printers Row Publishing Group
9717 Pacific Heights Blvd, San Diego, CA 92121
www.thunderbaybooks.com • mail@thunderbaybooks.com

Correspondence regarding the content of this book should be sent to Thunder Bay Press, Editorial Department, at the above address.

Publisher: Peter Norton
Associate Publisher: Ana Parker
Editorial Directors: April Graham, Diane Cain
Editor: Jessica Matteson
Production Team: Jonathan Lopes, Rusty von Dyl, Beno Chan

ISBN: 978-1-64517-290-1

Printed in China

28 27 26 25 24 3 4 5 6 7

![Disney]

VILLAINS
SPIROGLYPHICS®

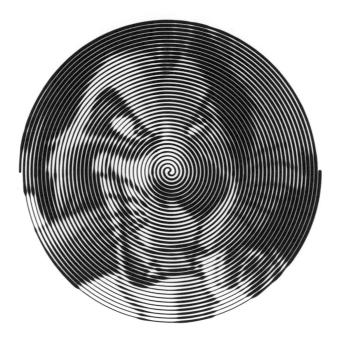

BEST–SELLING
AUTHOR

THOMAS
PAVITTE

THUNDER BAY
P·R·E·S·S

San Diego, California

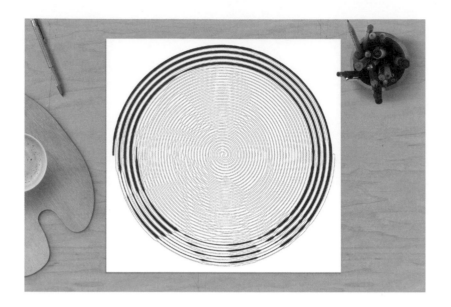
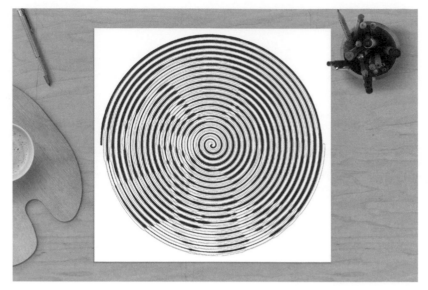

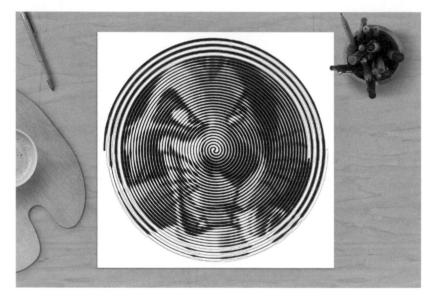

COLOR AND CREATE DISNEY VILLAINS WORKS OF ART

At first glance, spiroglyphics appear to be nothing but simple spirals. If you look a little closer, you'll see that the lines are two spirals, joined at the middle, varying subtly in width as they wind to the center. When you pick up a pen and begin to fill in the lines, a Disney Villain emerges!

INSTRUCTIONS

To create an element of surprise, choose any puzzle to begin. Or, you can refer to the puzzle key in the back of the book and pick your Villain. It's up to you how you approach it!

Choose one of the enclosed-loop ends on the outside of the spiral—the one on the left side of the puzzle or the right side of the puzzle—to begin. You can start on either side. Use your favorite marker or pen to fill in the lines and work your way around the spiral. When you reach the center of the spiral, stand back and take a look. Can you tell which Villain it is yet? Then, work your way back from the center to the outside and you'll see more details appear—like magic! As you stand back from the image, the Villain comes into focus.

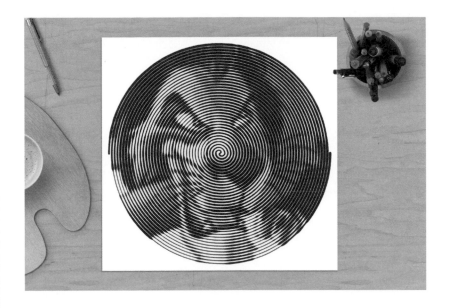

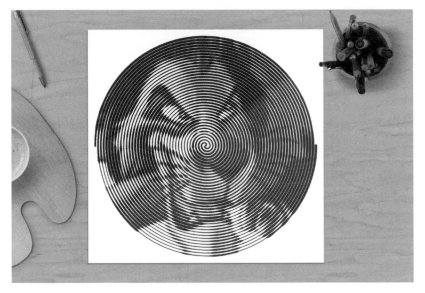

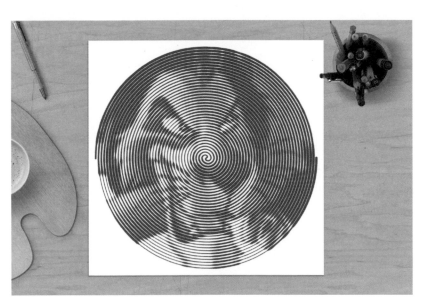

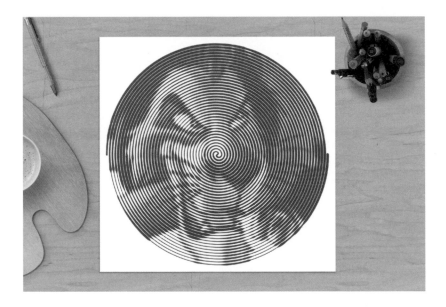

TRY THESE TECHNIQUES

The simplest way to create the spiroglyphics is with a black felt-tip pen for a monochromatic look, but there are endless variations you can try to achieve fun effects.

- After you've completed the image, go back and color in the white background spiral too. Try different color combinations, like contrasting colors or light and dark shades of the same color.

- Use realistic colors for a pop-art look. Give Yzma her signature purple color or King Candy his rosy, red cheeks.

- Divide the spiroglyphic into sections and use a different color for each part. You can split the puzzle in half or get creative with different shapes.

- Choose a number of rings to complete in one color then switch to another color to give your spiroglyphic a gradient effect.

START YOUR COLLECTION

Once you've finished a puzzle, carefully tear it out at the perforation line. Tweet, share, and frame your Disney Villains masterpiece!

2>

4>

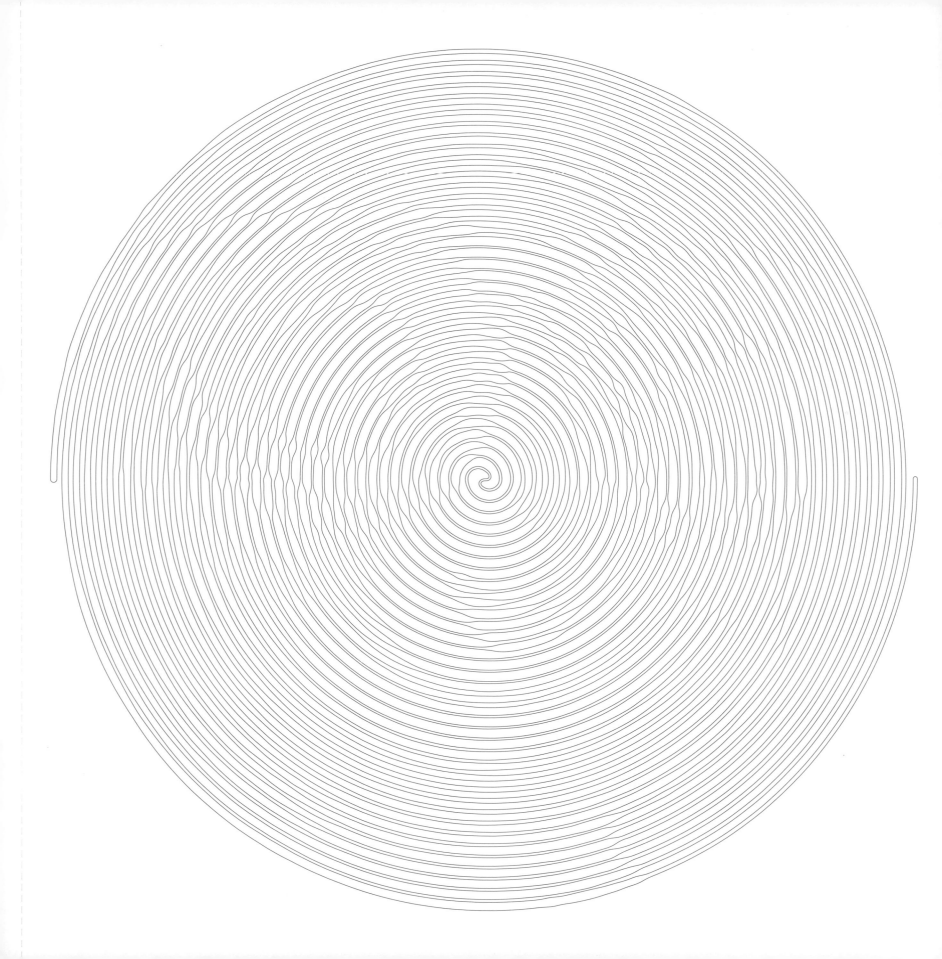

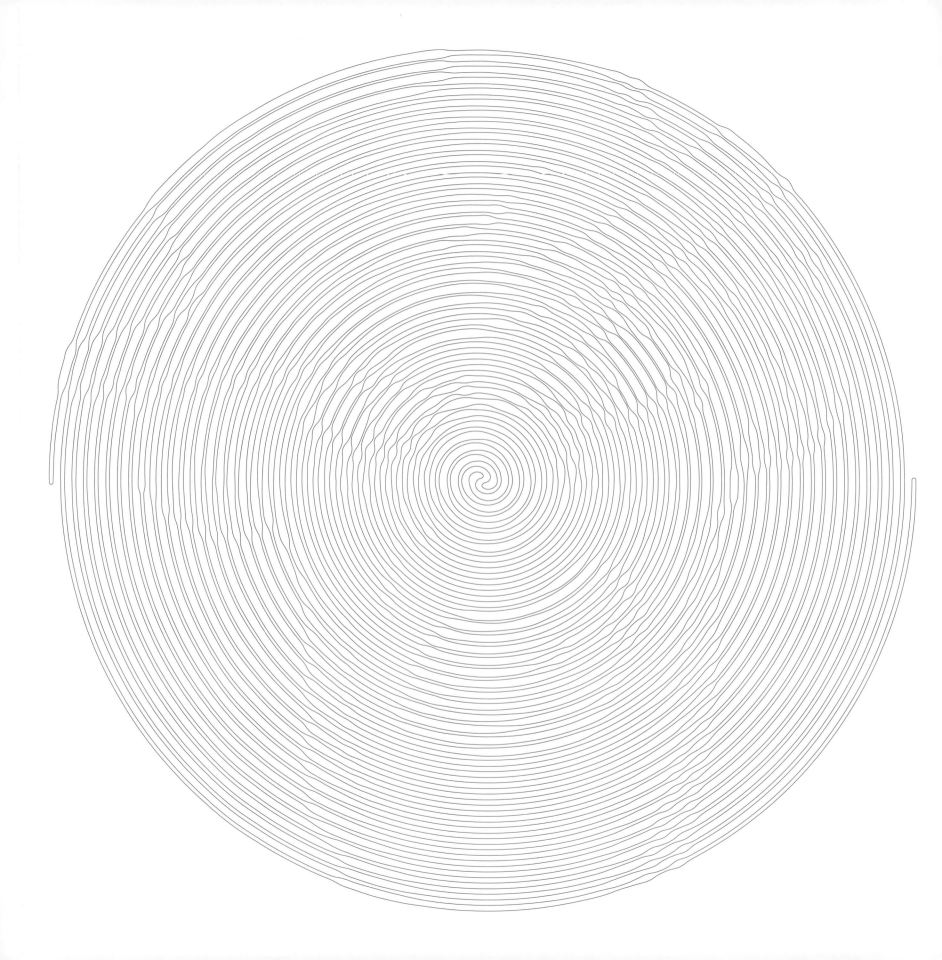

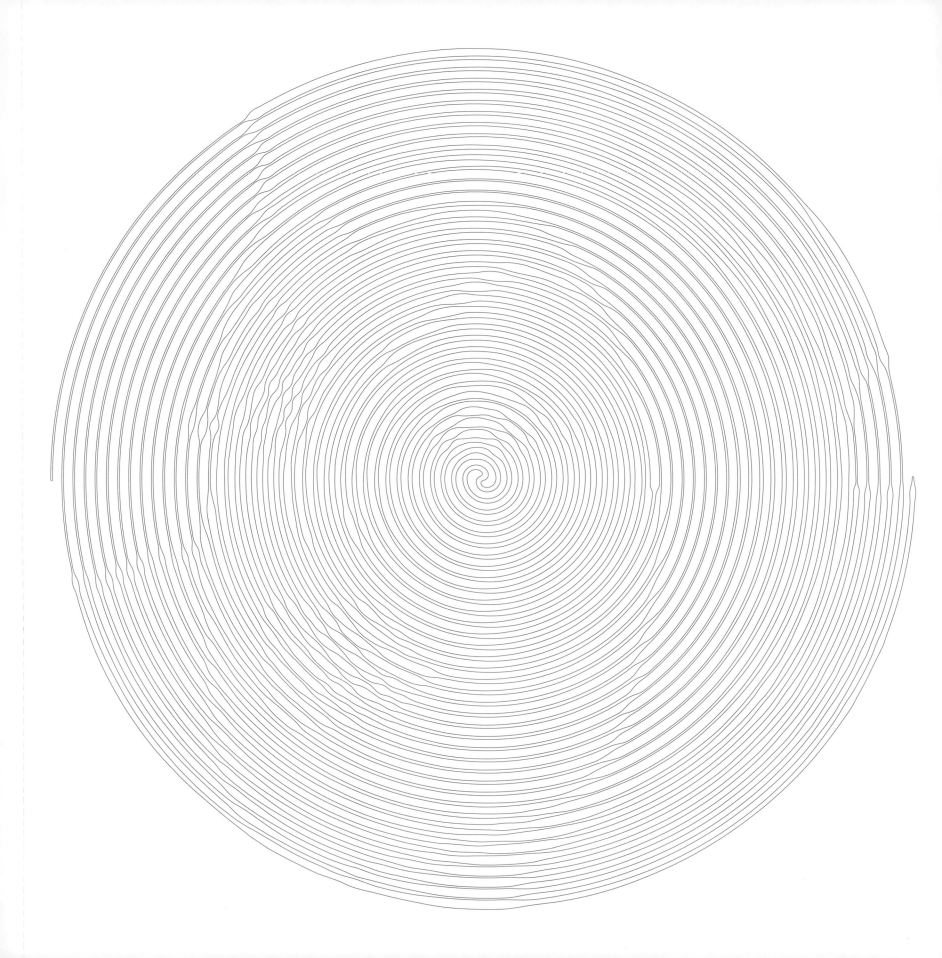

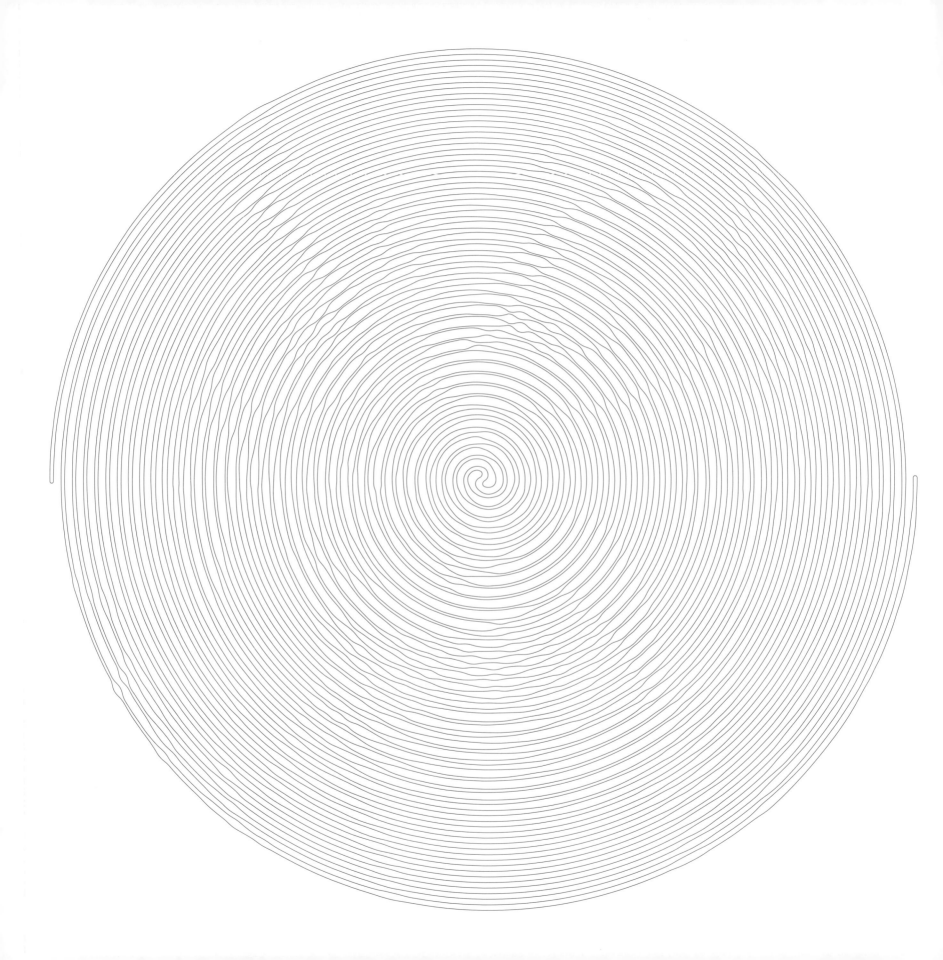

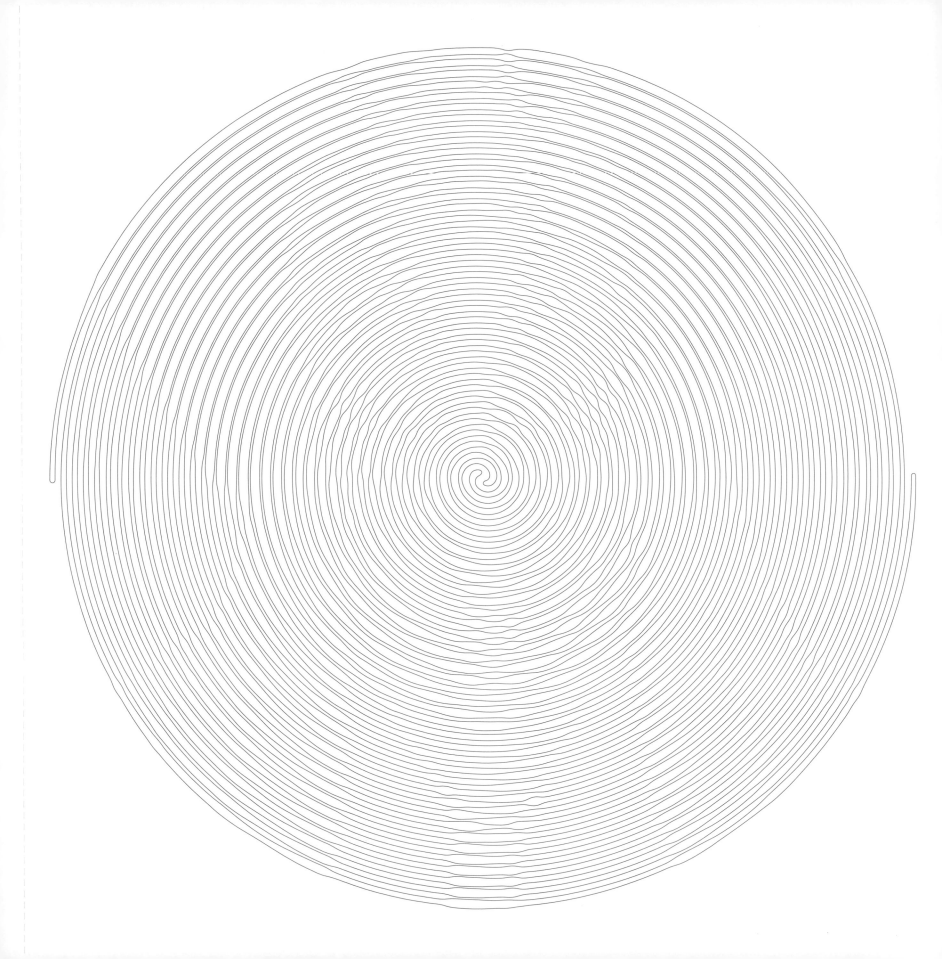

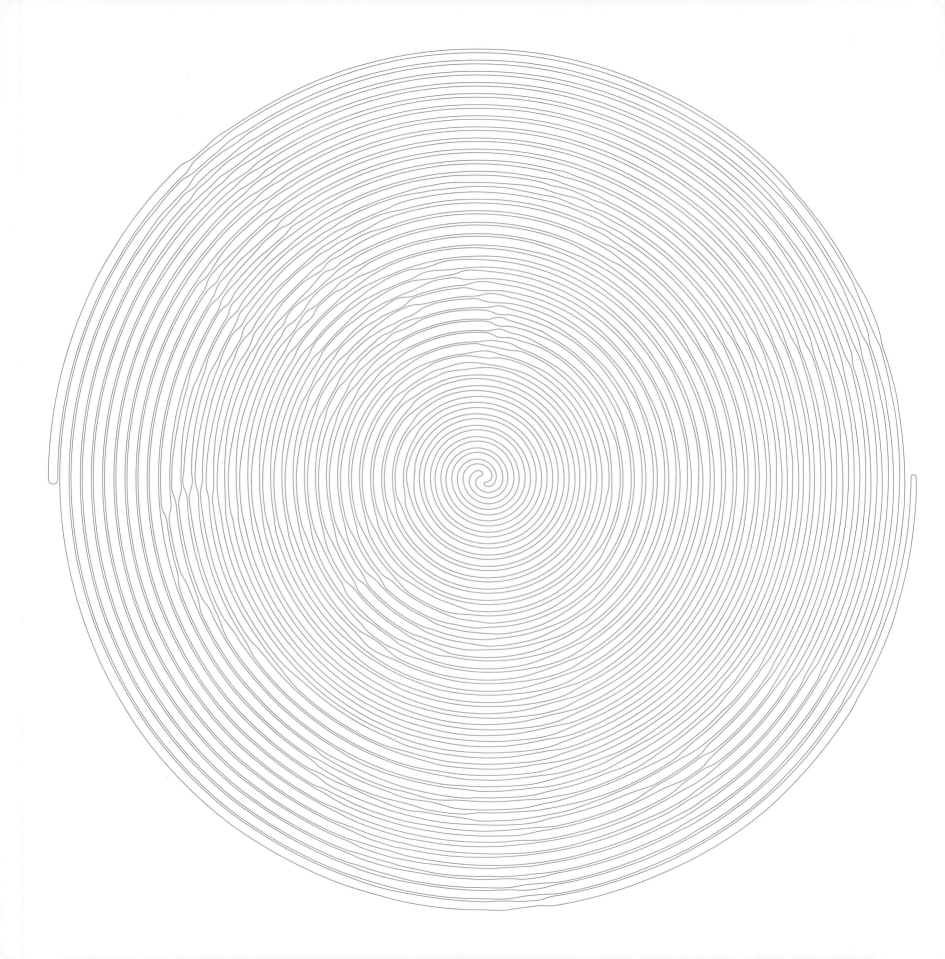

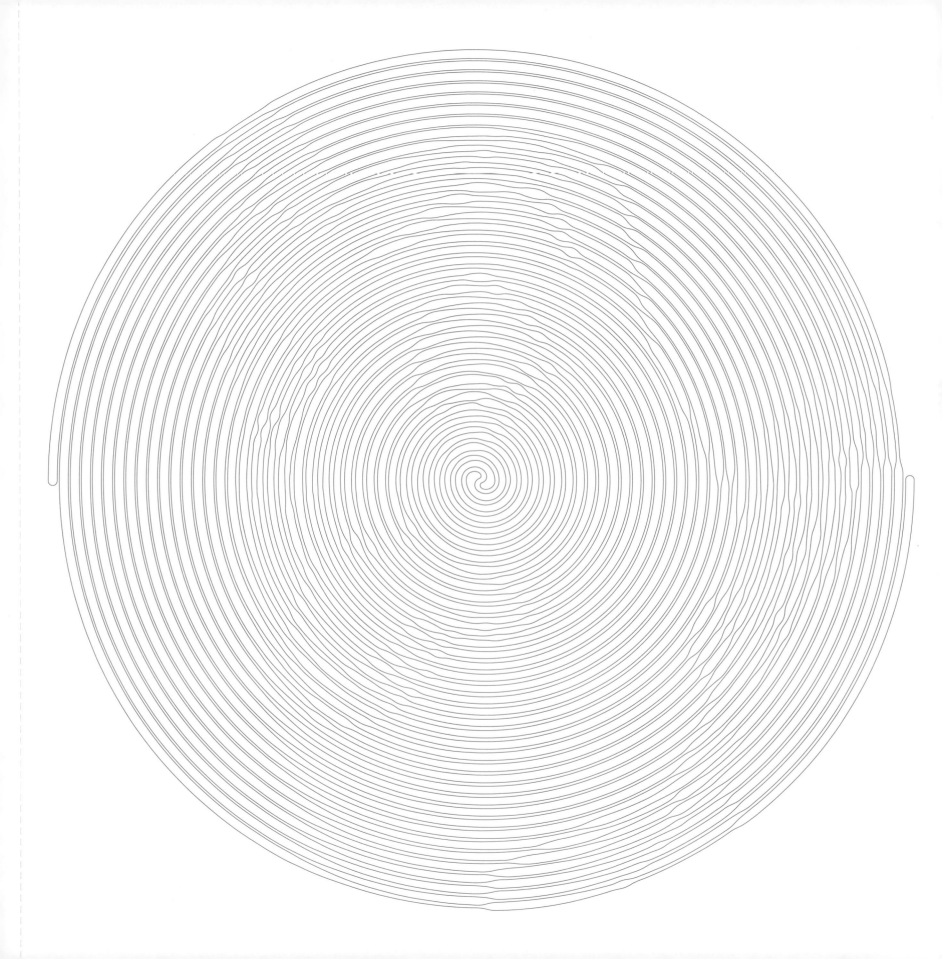

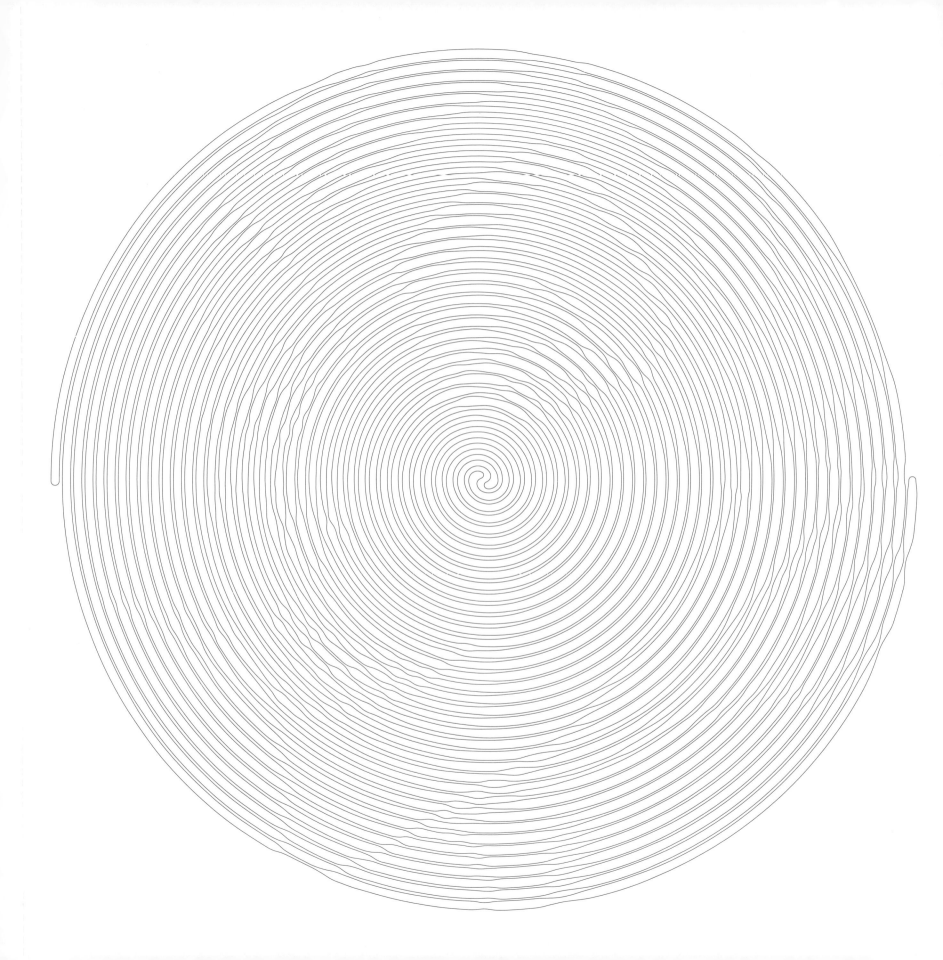

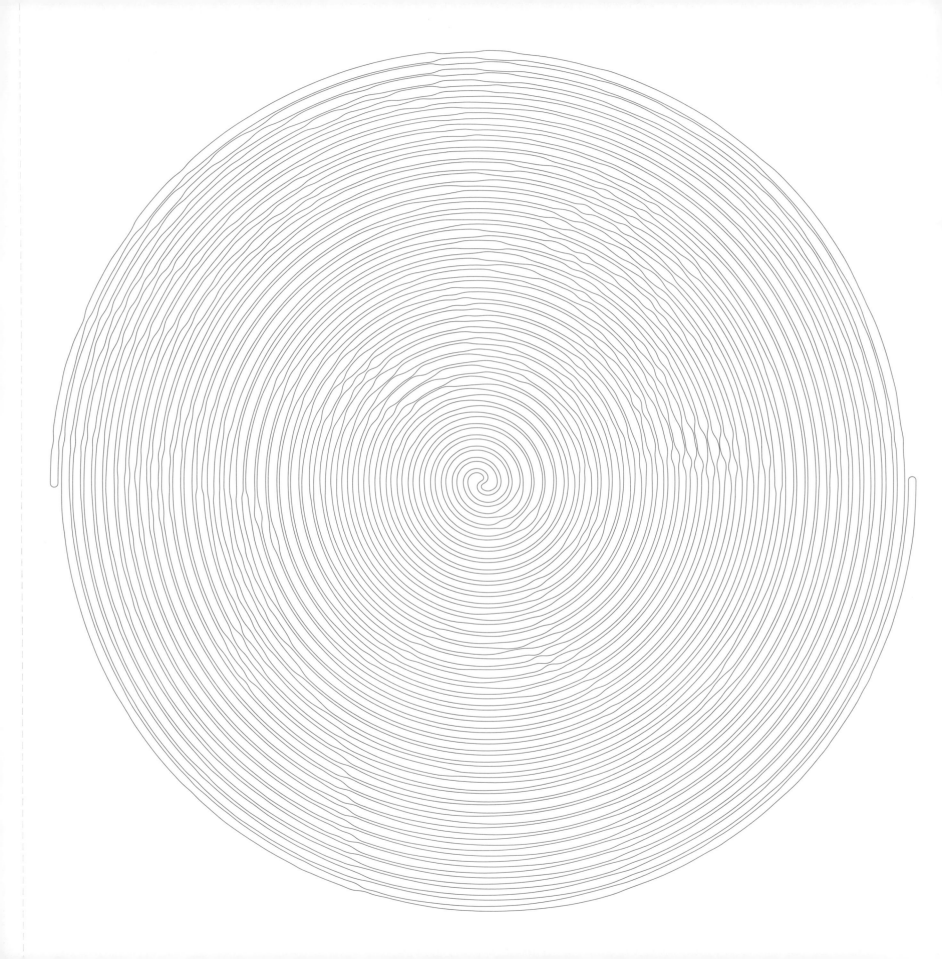

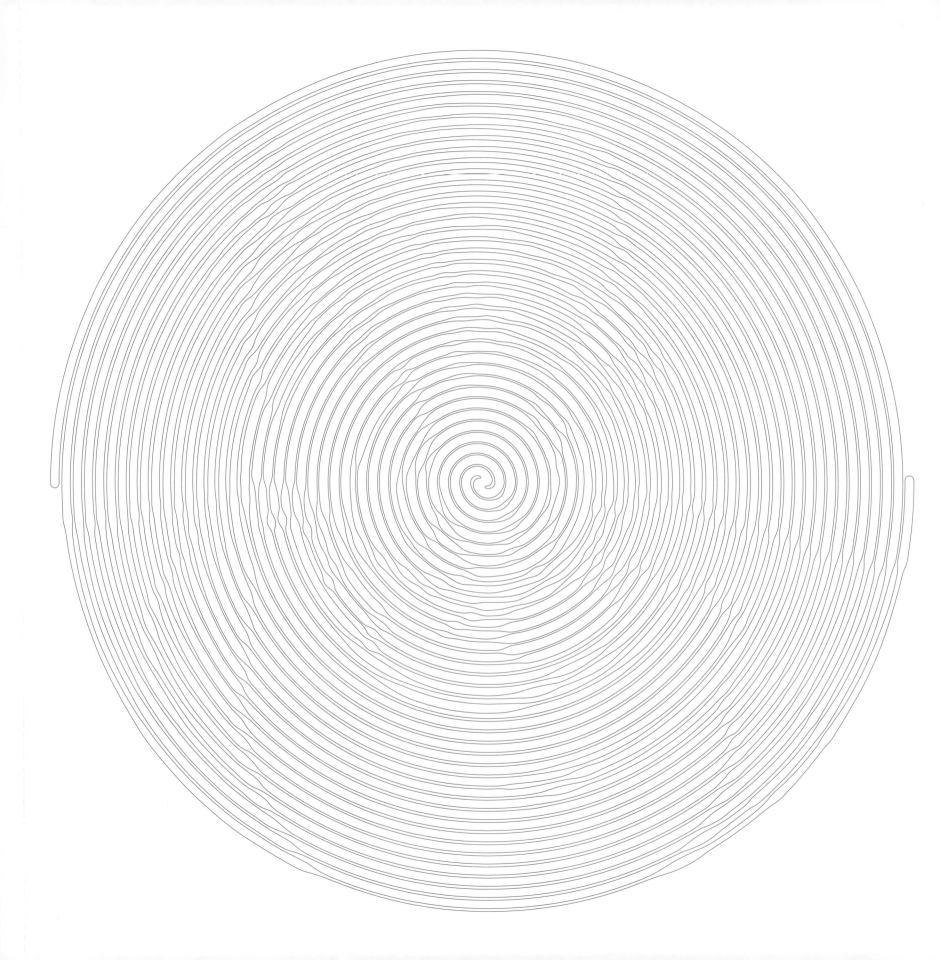

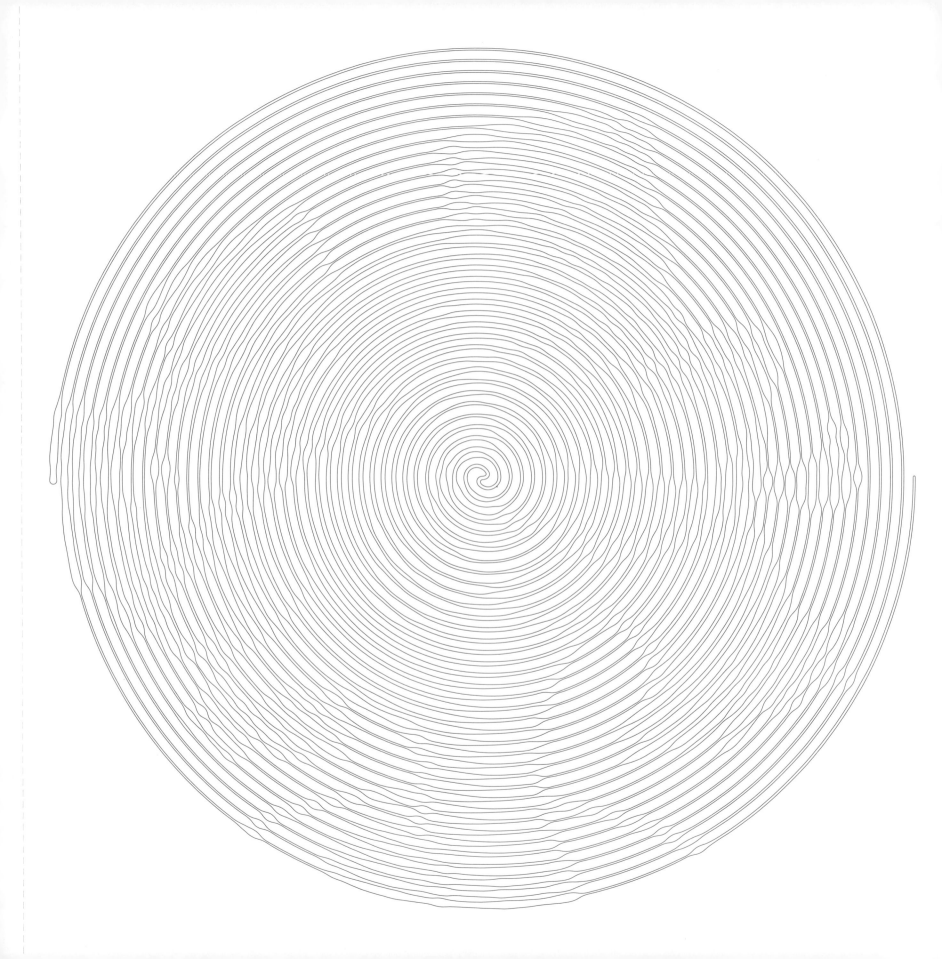

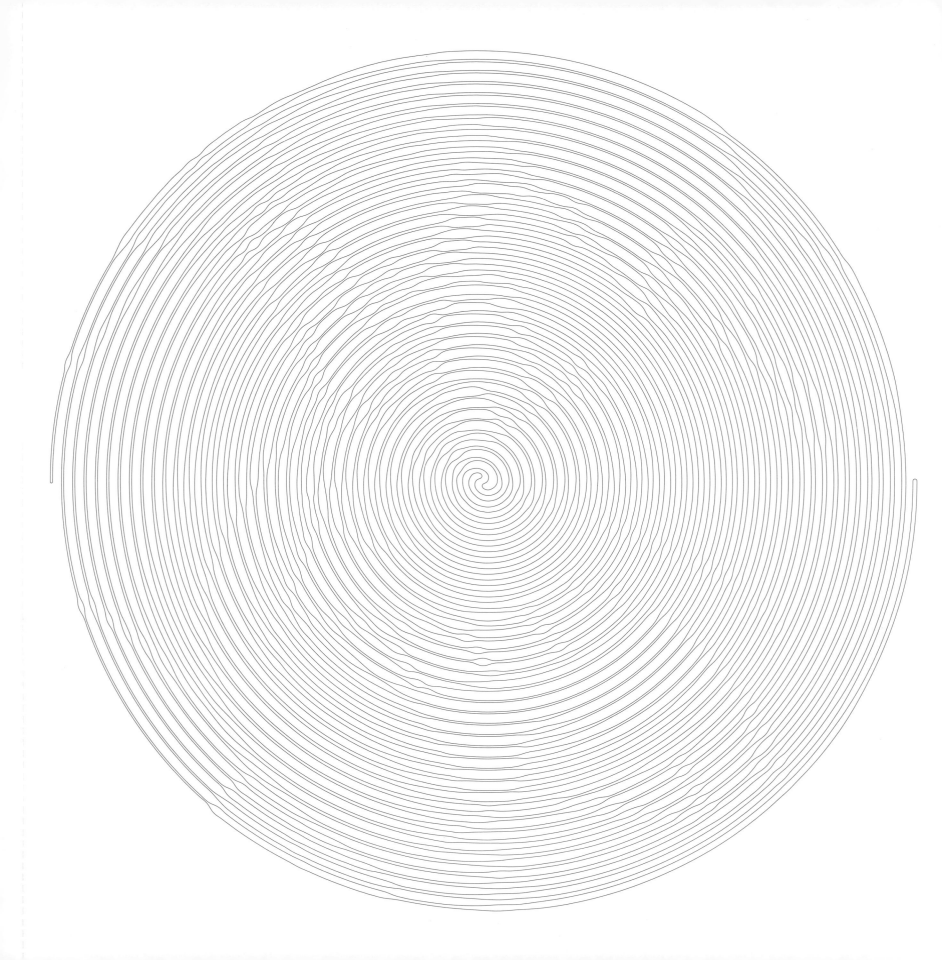

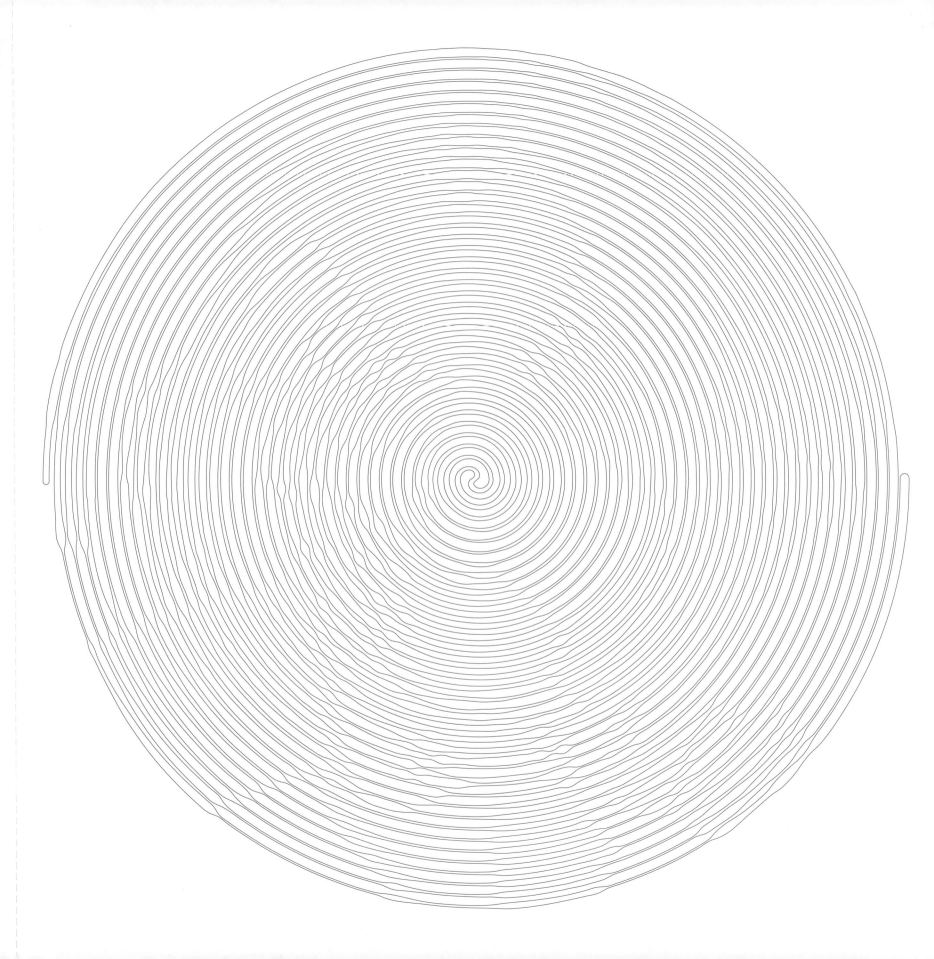

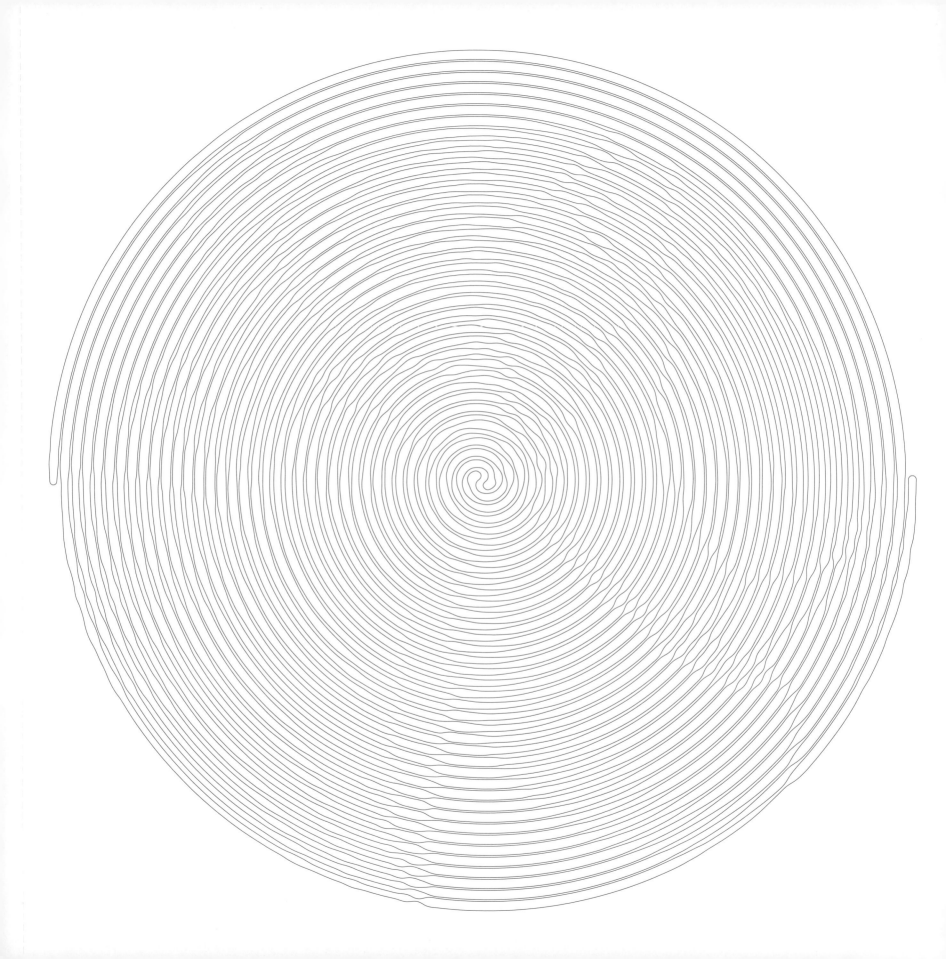

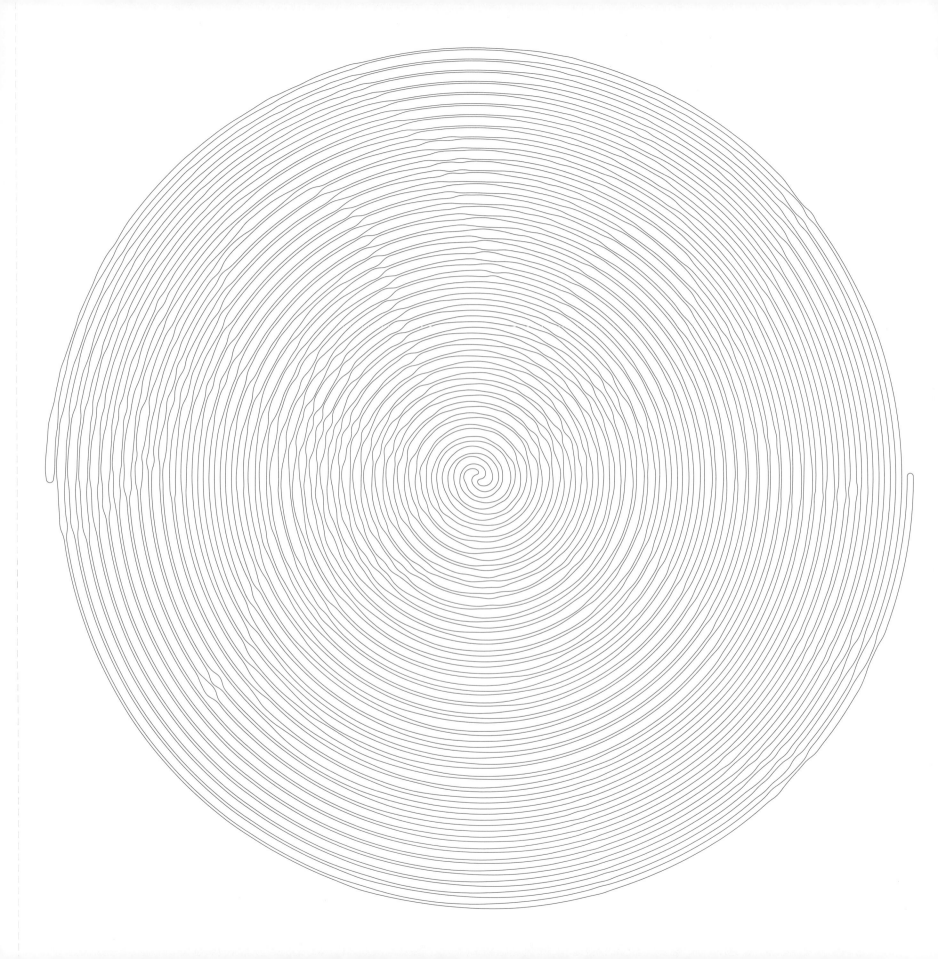

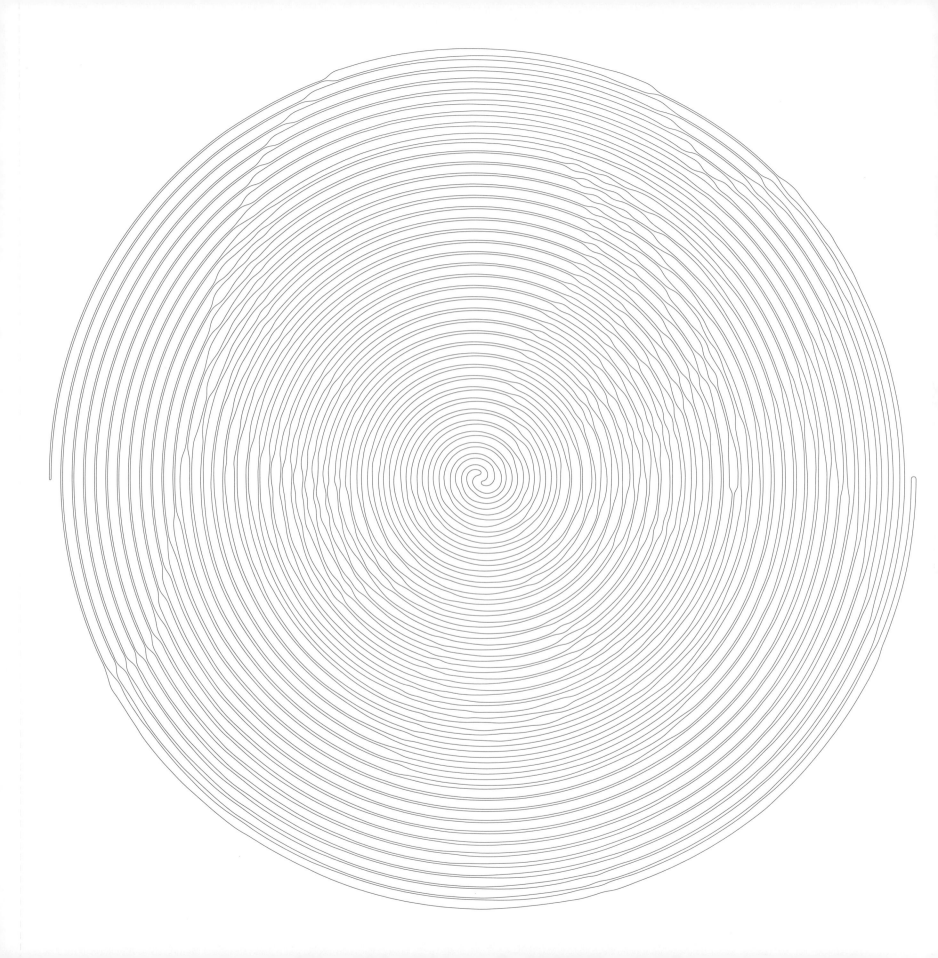

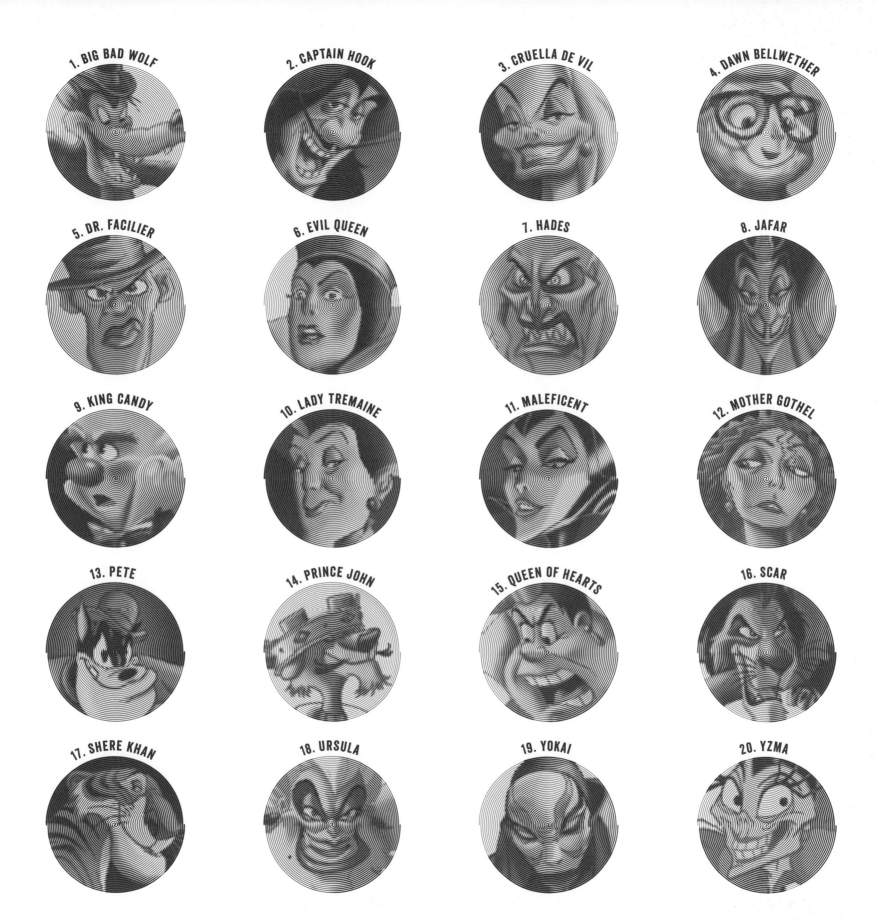

OTHER TITLES BY THOMAS PAVITTE:

1000 Dot-to-Dot: Animals
ISBN: 978-1-62686-085-8

1000 Dot-to-Dot: Cities
ISBN: 978-1-62686-066-7

1000 Dot-to-Dot: Icons
ISBN: 978-1-62686-065-0

Querkles: Animals
ISBN: 978-1-62686-785-7